THIS BOOK BELONGS TO:

Take the name of your very first pet, that gives you
your pornstar first name, and combine that with
the street you grew up on

■■■■■■■■■■■■■■■■■■■■■■■■■■■■■■■■■

nicotext

THE PORNSTAR NAME BOOK

Fredrik Colting (Slappy McClark)
Carl-Johan Gadd (Ramson Cain)

Edited by
Lara Allen (Sugar Ravenbush)

© 2005 NICOTEXT
www.nicotext.com
info@nicotext.com

Printed in Canada

ISBN 91-974883-2-1

FOREWORD
BY ALEXANDRA SILK

I know why you picked up this book. You think porn is cool. You want to know more - about sex, about the different ways people get off, about how somebody gets to do that all day. You want to know how to play, about the people whose job it is to have sex on film. Like me. Why? Why do you want to know? I bet *you* don't even know the answer to that question.

But I do, and there's more to it than just the fact that we, as porn stars, look hot and willing. It goes deeper. It's our confidence. We're like rock stars without clothes; we do all the things you want to do, but can't, or rather won't. We don't walk into a room; we strut like we own it.

We dance like we don't care if you're watching, we fuck like we don't get sick or tired or sore, we lie around naked, not caring about sagging tits, or big thighs or whether we've got wrinkles - and not just because we don't have any of those things.

We act like we know we look good, because we do, and that power, that confidence, makes us cool. You know it. We're everything you want to be and all the stuff you are but don't let show. It's in you, after all, every bit of what we show and do. You just don't like to admit it.

So you pick this up and read about it instead. Good for you. Maybe in the list of names you'll find a new identity, a new persona you can call yourself when you feel like letting your inner porn star loose. Maybe those stories about what happens behind the scenes and what we do, all that trivia, will inspire you to start exploring all that you've been hiding, all those secret desires. Maybe you'll get a new hobby. Maybe you'll begin to feel what people in the porn business have known all along
- you are one gorgeous, sexy mother fucker, and the world knows it. Now go out and get it.

www.alexandrasilk.com

'A Da Silva

Ace Slater

Adam West

Adam Wild

Adam Wood

Adina Jewel

Adrian Ace

Adrianna Breeze

Adrienne Almond

Africa Sexxx

Agent 69

Ahsly Foxxx

Aimee Sweet

Airyan Sinn

Ak Honey

Al Bruno

Alana Knight

Alex Divine

Alexandra Silk

Alexia Amore

Alexis Fine

Aliyah Likit

Allanah Star

Allisa Diamond

Alyssa Lovelace

sex trivia

The male fetus is capable of attaining an
erection during the last trimester.

A survey conducted by Masters and Johnson in the
early 1980s revealed that the third-most frequent
fantasy amongst both homosexual men and women
was a heterosexual encounter.

Hybristophilia:
Arousal derived by having sex
with people who have committed crimes.

According to the Kinsey Institute, half of the men
raised on farms have had a sexual
encounter with an animal.

Amanda Angel

Amazing Omar

Amber Lynn

Amia Amore

Amy Anus

Anastasia X

Andrea Dark

Andy Wild

Angel Ash

Angel Cake

Angel Hard

Angelica Sin

Anika LaRue

Anita Blond

Anita Dark

Anna Amore

Anna Malle

Annie Sprinkle

Anthony Bravo

Antonio Caronne

April Diamond

Arnold Schwartzen-pecker

Arthur Dix

Ashely Aspen

sex trivia

Egyptians inserted stones into their
vagina to prevent pregnancy.

In Medieval France, unfaithful wives were made to
chase a chicken through town while naked.

Napoleon's penis was sold to an
American Urologist for $40,000.

Seventy percent of women would
rather have chocolate than sex.

Ashley Foxx

Asia Carrera

Ataria Starling

Axl Hose

Bambi Bliss

Barbara Dare

Barrett Bangwell

Bebe LaBadd

Bethany Starr

Betty Boobs

Beverly Cox

Bianca Pureheart

Bibi Fox

Billy Q Brilliantes

Biff Malibu

Bionca Danger

Blake Powers

Blondie Anderson

Bobbi Bliss

Brockton O Toole

Brook Waters

Brooke Ballentyne

Bruce Vain

Buck Adams

Bobby Blake

Bonnie Heart

Brandon Steele

Branna Blaze

sex trivia

The word "avocado" comes from the Spanish word "aguacate" which is derived from the Aztec word "ahuacati" which means testicle.

In Harrisburg, Pennsylvania, it's against the law to have sex with a truck driver in a toll booth.

In Fairbanks, Alaska it's illegal for moose to have sex on the city sidewalks.

In Florida having sexual relations with a porcupine is illegal.

Brent Rockman

Britney Lixx

Brittaney Blue

Brittany Morgan

Buffy Sinclaire

Bunny Glamazon

Butch Vaughn

Byron Long

Calli Coxx

Cameron Cruise

Camila Costa

Candee Lopes

Candi Cotton

Candi Roxxx

Candy Fox

Caramel Candy

Caressa Savage

Carla Amour

Carly Sparks

Carmen Del Rio

Caroline Cage

Carrie Cash

Casey Minx

Cassandra Wild

Cassidy Coxx

Ceasar Cruz

Chad Conners

Charise Lamour

sex trivia

According to *Playboy*, the most popular
sexual aid is erotic literature.

One of the reasons male deer rub their antlers
on a tree or the ground is to masturbate.

Approximately one out of every two hundred
women is born with an extra nipple.

A small flaccid penis generally has a greater
percentage increase during erection than
a larger flaccid penis.

Charlie Mack

Chasey Lain

Chaz Chase

Cheri Hill

Cherokee Lynn

Cherry Lane

Chessie Moore

Chi Chi LaRue

China Lee

Chiquita Lopez

Chocolate Star

Chris Black

Chrissy Sparks

Christa Rain

Christina Rio

Christopher Clark

Christy Canyon

Chuckie Woods

Cindy Fox

Cinthia Cruz

Clarissa Climaxx

Claudia Chase

Claudio Clio

Cleo Mist

Coco la rocco

sex trivia

Wyoming's Grand Tetons mountain range
literally means "Big Tits".

In the original Grimm's fairy tale "Sleeping Beauty",
the Prince rapes her while she sleeps and then
leaves before she wakes up.

The word 'gymnasium' comes from the Greek word
"gymnazein" which means to exercise naked,
which often was done in ancient Greece.

White women and those women with a college degree,
when asked, said they were more receptive to anal
sex than women without college educations.

Cody Cruise

Corina Curves

Courtney Cummings

Crissy Sparks

Cristina Blond

Cyndee Steele

Cynthia Fox

D Lava

D Light

Dafney Sweet

Daisey Fox

Daisy Dukes

Dale DaBone

Dallas D Amour

Damion Black

Dan Stallion

Dani Blonde

sex trivia

14% of males said that they did not enjoy sex the first time.

60% of women say they did not enjoy sex their first time.

The Romans would crush a first time rapist's gonads between two stones.

It's illegal to have sex with a corpse anywhere in the United States.

Daniella Rush

Danielle Dynamite

Danika Wilde

Danny Danger

Danya Cannon

Daphne Moore

Darby Fox

Darla Derriere

Darling Le Conte

Dave Cummings

Dave Hardman

David Dickens

David Hardwood

Dawn Burning

Dawn Devine

Dayton Rains

Dean Randy

Debbie Diamond

Deborah Dick

Dee Licious

Delphine Delage

Derek Newblood

Deseree Dupree

Destiny Diamond

Devon DeRay

Deja Blew

Diamond Dick

Dian Bravo

Dian Pearl

Dick Delaware

Dick Rambone

Dildo Danny

Dirk Diggler

Dizzy Blonde

Dolly Dott

sex trivia

Casanova boasted that he made love to the same woman twelve times in one day.

In general, women who are housewives are more faithful than working women.

Among sexually active adults, lesbians have the lowest incidence of sexually transmitted diseases.

The average bra is designed to last for only 180 days of use.

sex trivia

Up until 1884, a Victorian-era woman could be sent to prison for denying a husband sex.

Taking the act of adultery to very painful heights, the Serni of Brazil take a guilty wife, whip her and then expose the wounds to fire ants.

During the Middle Ages, if you were guilty of bestiality you'd be burned at the stake, along with the other party to your crime.

The Asiatic Huns punished convicted male rapists and adulterers with castration. Female adulterers were cut in two.

Dominique
de Lorean

Dirty Diana

Donald Hump

Donny Blast

Donovan Dance

Dorothy Love

Douglas Drake

Drew Darling

Dwayne Cummins

Ebony Ayes

Ed Powers

Eden Rae

Edina Blonde

Effie Balconi

Electra Angel

Elizabeth Shy

Elle DeVine

Elsa Bangz

Emily Divinci

Eric Frost

Eric Masterson

Erika Bella

Eros Cristaldi

Essy Moore

sex trivia

The practice of autoerotic asphyxiation
(temporarily suffocating or strangling yourself while
masturbating) takes the lives of 250 to a thousand
people each year.

A "buckle bunny" is a woman who goes to rodeos
with the intent of having sex with a rodeo cowboy.

Human testicles can increase in size by
50% when a man is aroused.

The word "sex" was coined in 1382.

Esther Virgin

Ethan Starr

Eva Angel

Eva Blonde

Eva Moore

Fabiane de la Costa

Fabio Modena

Faith Lamour

Fallon Sommers

Faith Adams

Fausto Moreno

Fawn Paris

Felcia Fox

Felecity Jones

Felicia Ryder

Felix Vixious

Felony Love

Fenix Starr

Finess Navaro

Fiona Bones

Flint Striker

Francesca Lipps

Francesco Malon

Franco Roccaforte

Frank Gun

Frankie LaRue

Freddy Dalton

Fuka Katayama

Gabriella Banks

Gabrielle Scream

Gaby Black

Gail Force

Gary Boon

sex trivia

A bull can inseminate 300 cows from one single ejaculation.

The sperm of a mouse is actually longer
than the sperm of an elephant.

Sex education was first introduced into
English schools in 1889.

Cleopatra invented her own diaphragm
from camel's poop.

Genevieve DeKay

Genna Blue

Geoffrey Coldwater

Gia Darling

Gidget The Midget

Gigi Ferarri

Gina Best

Gina Blonde

Gina Fox

Gina Lynn

Gina Share

Ginger Licks

Gino Greco

Giovanni Valente

Giselle Yum

Giuseppe Gogo

Glitter Divine

Gloria Gucci

Gold Chain Rupert

Goldie Locks

Grace Swallow

Gregg Steel

Gwen Summers

Hailey Starr

Haley Sweet

Halli Ashton

Hamilton Steele

Hank Hollywood

sex trivia

Homosexuality remained on the American Psychiatric Association's list of mental illnesses until 1973.

The smallest erect penis on record was one centimeter long.

Women who respond to sex surveys in magazines have had five times as many lovers as non-respondents.

In 1995, Mo Ka Wang, a Chi Kung master in Hong Kong, lifted over 250 pounds of weight two feet off the floor with his erect penis.

Hannah Hunter

Hardman Henry

Harley David

Harley Raines

Hazel Young

Heather Heels

Heaven St Claire

Heavinly Hotts

Heidi Ho

Heidi Rains

Helen Bed

Henchman Peter

Henrietta Blond

Hermony Grant

High Pitch Eric

Hollie Woods

Holly Bush

Holly Heels

Holly Ryder

Honey Bunny

Honey Moons

Hope Stockton

Howard Ramone

Howie Ballboa

Hugo Ferrari

sex trivia

The same chemical responsible for the ecstatic highs
of love and sexual attraction, phenylethylamine,
is also found in chocolate.

Oneirogmophobia:
Is the fear of wet dreams.

A parthenologist is someone who specializes
in the study of virgins and virginity.

A capon is a castrated rooster. They are said to have more
tender meat when cooked and that's why they cost more.

Two of the main causes of temporary impotence are
tight pants and prolonged cigarette smoking.

Hunk Dermon

Hunter Young

Hyapatia Lee

Jan Scott

Ice Cream

Ice La Fox

Igor Ivy

Illana Moore

Ilona Staller

India Allen

Ingrid Swede

Isabel ice

Isabelle Bond

Isadora Rose

Isis Delight

Ivory Blaze

Ivy Rae

Jack Hammer

Jackeline Biaggi

Jackie Moore

Jacklyn Lick

Jacqueline Du Moan

sex trivia

Iatronudia:
Doctor, doctor! This person loves
exposing him or herself to a physician.

Lactaphilia:
Mammaries full of milk don't make just babies happy...

Podophilia:
This fairly common fetish finds folks getting
hot and bothered about feet. To each his own.

Retifism:
Turned on by shoes.

Parthenophilia:
These people have a desire to deflower virgins.

Jada Fox

Jade Stone

Jagger Haze

Jake Ryder

Jamie Fuckingham

Jamie Monroe

Jamie Woods

Jammie Sparks

Jane Bond

Jane Doe

Janet Jacme

Janey Lamb

Janie Foxxx

Jasmine Rouge

Jason Silver

Jayce Addams

Jayla Bait

Jayne Diamond

Jazmine Lynn

Jean Kelli

Jean Pierre Armand

Jeanette Desire

Jeanie Peppers

Jeanna Fine

sex trivia

Nasophilia: is the arousal from the sight, touch, licking, or sucking of a partner's nose.

It is illegal for anyone under the age of 18 to pose for a pornographic magazine, movie or web site in the USA.

Timmie Jean Lindsey of Houston, TX became the first person to get silicone breast implants in 1962.

Studies have proven that it's harder to tell a convincing lie to someone you find sexually attractive.

Jees Jane

Jeff Butler

Jen Teal

Jenna Jameson

Jennifer Dark

Jenny McArthur

Jenny Rider

Jeremy Irons

Jerk Douglas

Jesse Jane

Jessica Cummins

Jessica Drake

Jessica Fiorentino

Jessica Fox

Jessica Wilde

sex trivia

8.5 billion condoms are produced every year worldwide.

Graham crackers were once believed (and in some cases used) to reduce sexual arousal and desire.

A man' penis can stay constantly erect, by applying camel's milk and honey, according to the "Kama Sutra".

Three out of a thousand men (0.3%) are well endowed enough to fellate (blow) themselves to orgasm.

Jessica Young

Jessie James

Jet Richards

Jezebelle Bond

Jimmy Lee Sparks

Jocelyn Pink

Jodie Moore

Joe Cool

John Holmes

John Stagliano

Johnny Jewels

Josie Lynn

Joy Wood

Judit Young

Judy Starr

Juilano Ferraz

Jules Jordan

Julia Fox

Julie Juggs

Kamie Woods

Kamil Klein

Kandee Loupes

Kandi Cox

Kandi Kane

Kara Knox

Karen Stone

Kari Kums

Karina Play

Karl Kinkaid

Karol Castro

Kary Evers

Kat Kleavage

Kate Kaptive

Katherine Count

Kathrina Kraven

Katia Love

Katie More

Katja Kean

Kayla Coxx

Kayla Kleevage

KC Lane

Keegan Sky

Keke Kanyon

Keli Klean

Kelli Sparks

Kelly Cocks

Kelly Kummings

Kendall Starr

Kerri Downs

sex trivia

Crematistophilia:
Is the arousal from being charged for sex.

Dacryphilia:
Is the arousal from seeing tears in the eyes of a partner.

Oculolintus:
Is the act of licking a partner's eyeball.

Sacofricosis:
Is the practice of cutting a hole in the bottom of a
front pants pocket in order to masturbate in public
with less risk of detection.

Taphephilia:
Is the arousal from being buried alive.

Kevin King

Kiki Kanyon

Kikki Lixxx

Kim Colt

Kim Kummings

Kimberly Kupps

Kirsten Kane

Kitty Divine

Kitty Monroe

Kodak Kidd

Koko Brown

Kris Knight

Krista Lane

Kristina Blond

Kristina Young

Krysty Lynn

Krystal Summers

Kurt Hardwood

Kyla Fine

Lacey Legends

Lacey Lippz

Lana Blake

Lana Lynx

Lance Banger

Lance Landers

Larissa Sweet

Lasha Lane

Laura Dark

Laura LeClaire

sex trivia

Oral and anal sex are illegal in many states in the US, between both homosexual and heterosexual people.

The hymen is named after the Greek God Hymenaeus - the God of marriage and weddings.

A pig's orgasm can lasts for about 30 minutes.

In 2004, a sex toy was introduced that does not require batteries: it connects to a USB port.

Lauren Legends

Layne Young

Leah Masters

Leanna Foxx

LeeAn Lovelace

Leila Swan

Lena Ramon

Lenny Powers

Lexi Lamoure

Lexi Lane

Lilith Rose

Lilly Lovly

Linda Lipps

Linda Lovelace

Lindsey Delight

Lisa LaMoore

Lisa Lipps

Lola Ferrari

Loretta Sterling

Lori Turner

Luke Wilder

Luca Valentini

Lucy Love

Lydia Styles

Madelyn Knight

Magenta May

Mahogany Sweets

Mallory Marx

Mandi Belle

Mandy Frost

Manny Moore

Marc Cummings

Maria Bellucci

Marilyn Star

Marina Montague

Marissa Malibu

Mark Stone

Martina Mercedes

Mary Lou

sex trivia

Mosquitoes, which mate in the air perform
a sex act that lasts only 2 seconds.

Women with a Ph.D. are twice as likely to be interested in a
one-night stand than those with only a Bachelor's degree.

Fellatio ranks as the number one sexual
act desired by heterosexual men.

Australian women have sex on the first date more than
women the same age in the USA and Canada.

Mason Storm

Matilda Moon

Matt Drillum

Max Hardcore

Maxi Mounds

Maxine Monroe

Maya Divine

Melanie Blaze

Melissa Pink

Melodie Mitchell

Mia Fox

Michael J. Cox

Michael Maclaine

Michele Wild

Mickey Monroe

sex trivia

Humans, fish and porpoises share a common
sexual practice - fellatio.

While nudity was considered commonplace to the ancient
Greeks, a man was considered indecent if he had
an exposed erection.

Honking of car horns for a couple that just got married
is an old superstition to insure great sex.

The most successful X-rated movie of all time is
"Deep Throat". It cost approximately $25,000 to make
and has earned more than $600 million dollars.

Mika Mayze

Mike Pitts

Mike Stallone

Miko Lee

Mimi Deville

Mischel Wild

Missy Marie

Misty Devine

Misty Hayes

Molly Malone

Monica Bella

Monique DeMoan

Montana West

Morgan Fairlane

Murrie Turmain

Nadia Nice

Natalie Stone

Natasha Blake

Nick Manning

Nena Cherry

Nic Wilde

Nicholas Fox

Nici Blond

Nici Sterling

Nick Dauntless

Nick Nasty

Nicki Steele

Nicoletta Jns

Niki Knox

Nikita Rush

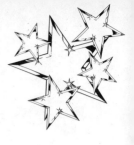

sex trivia

Minks have intercourse that lasts
an average of eight hours.

The chimpanzee holds the record for the quickest mammal
sexual intercourse session at an average of three seconds.

Most turkeys and giraffes are bisexual.

An adult gorilla's penis is only two inches long.

Nikki Diamonds

Nina Hartley

Nina Sweet

Ocatavia Hunter

Chara Sunshine

Olga Saint Martin

Olive Berry

Olivia Chase

Olivia Parrish

Omar Montana

Oscar Wilde

Owen Bucks

Pablo Martini

Page Powers

Paisley Hunter

Pal Paris

Pamela Peaks

Paris Rain

Pat Bull

Patricia Diamond

Patricia Petit

Patti Amor

sex trivia

Everyday, 200 million couples around the world have sex, which is about over 2000 couples at any given moment.

Women are most likely to want to have sex when they are ovulating.

It was during the Victorian era that the formerly nude Cupid was redesigned as wearing a skirt.

30% of women over the age of 80 still have sexual intercourse either with their spouse or boyfriends.

Paul Stryder

Paula Price

Payton Price

Penelope Pumpkins

Penny Flame

Peter North

Petra Blond

Phoenix Ray

Phil Holiday

Pierre Woodman

Piston Pete

Poppy Morgan

Porshe Lynn

Priscilla Payne

Queen Ray

Queenie Pipes

Quentin Tagliano

Quincy May

Rachel Moore

Rafaela Buckman

Rain Rivers

Randy Lee

Randy Ravage

Randy West

Raquel Delight

Raquel Ryan

Raven Alexander

Ray Swayze

sex trivia

The original representation of Cupid by the Greeks was that of a beautiful young boy whose naked form was considered to be the embodiment of sexual love.

The first condoms in the US were made from vulcanized rubber in the 1870s. They were expensive and annoyingly thick and meant to be reused.

Women who went to college are more likely to enjoy both the giving and receiving of oral sex than high school dropouts.

About 1% of the adult female population are able to achieve orgasm solely through breast stimulation.

Rebecca Lord

Remy Martin

Rene Romero

Rianna Star

Ricardo Bronco

Richard Delaware

Rick Rough

Ricky Lee Parker

Rikki Ray

Rita Ricardo

Rob Danger

Robin Wood

Rocco Siffredi

Rocki Roads

Rod Steele

Ron Jeremy

Ronnie Cox

Rosie Rocket

Roxy Foxx

Roxy Rider

sex trivia

Thlipsosis:
Turned on by pinching.

Gerontophilia:
An attraction to the old and enfeebled.

Chremastistophilia:
This person gets off on the idea of being robbed.

Coulrophilia:
When you want a clown to
entertain your pants off.

Roy Rogers

Ruby Richards

Ryan Block

Sable Holiday

Sabrina Dawn

Sadie Belle

Sahara Sands

Sahron Wild

Sally Laid

Sam Shaft

Samantha Fox

Samantha Silk

Sammy Sabel

Sandi Beach

Sandra Irons

Sandra Scream

Sandy Shores

Sara Dark

sex trivia

Axillism:
Is the act of using of the armpit for sex.

Emetophilia:
Is the arousal from vomit or vomiting.

Siderodromophilia:
The arousal from riding in trains.

Anasteemaphilia:
The attraction to a person
because of a difference in height.

Sarah Sin

Sarah Young

Sasha Knox

Savanah Rain

Savanna Staxx

Scarlet Haze

Scott Styles

Sean Diamond

Sean Rider

Selena Sosa

Serena Saunders

Seymore Butts

Shannon Wylde

Sharon Blush

Shauna Banks

Sheena Horne

Sheila Stone

Shelby Star

Shelly Shore

Sheryl Lynn

Sidney Lamarr

Sierra Cruz

Silvia Boots

Silvia Saint

Sinamon Lane

sex trivia

The penis of a dragonfly is shaped like a shovel, and has the ability to scoop out a male rivals semen.

The word pornography comes from the Greek meaning the "writings of prostitutes".

In Ancient Greece, women would expose their vaginas to ward off storms at sea.

In ancient Greece and Rome, dildos were made out of animal horns, gold, silver, ivory and glass.

Sissy Sweet

Sky Lopez

Skylar Knight

Slim Goody

Snake Sullivan

Sofia Santos

Sonya Red

Spencer Benedict

Stacey Lords

Starr Nelson

Stefany Steel

Steve Hopper

Steven Adore

Stevie Licks

Sue Diamond

Summer Lynn

Sunset Thomas

Susan Hart

Sydney St James

Sylvia Sandz

T

Tabitha Cash

Tamara Lee

Tami Lynn

Tanja Wilder

Tara Thigh

sex trivia

The first public strip-tease dance was
performed in Paris in 1894.

In Ventura County, California, cats and dogs
are not allowed to have sex without a permit.

In Newcastle, Wyoming, an ordinance specifically
bans couples from having sex while standing
in a store's walk-in meat freezer.

Tasha Taylor

Tawny Lyons

Tequila Jade

Teresa Tease

Teri Diver

Texas Tyler

Thomas Moore

Tia Carrere

Tiffany Clark

Tiffany Lords

Tiffany Minx

Tiffany Tease

Tiger Lilly

Tim Tiny

Tina Tyler

Titus Steel

TJ Cummings

Tom Byron

Tony Baloney

Tony Ryder

sex trivia

It's illegal to have sex without a condom in Nevada.

Today, Japan leads the world in condom use. Like cosmetics, they're sold door to door, by women.

More Americans lose their virginity in June than in any other month.

A man's penis not only shrinks during cold weather but also from nonsexual excitement like when his favorite football team scores a touchdown, etc.

Tonya Grace

Tori Wells

Traci Lane

Trent Cocker

Trinity Loren

Trixie Tyler

Troy Michaels

Tyler Woods

Tyson Bedrock

Ursula Moore

Valentina Vain

Valerie Venus

Vanessa Bacon

Vanessa del Rio

Vanessa Sparks

Vanilla Thompson

Vega Valerie

Venus Milan

Veronica Brazil

Veronica Rio

Vic Sinister

Vicci Valencorte

Vickie Powell

Vicky Salas

Victor Willis

Victoria Givens

Victoria Styles

Victoria Vixen

Vikki Blonde

Vince Logan

sex trivia

Formicophila:
Is the enjoyment of the use of
insects for sexual purposes.

Dendrophilia:
Is a sexual attraction to trees.

Agalmatophilia:
Is an attractions to statues or mannequins.

Plushophilia:
Is the attraction to stuff animals or the act
of intercourse with a stuffed animal.

Vinnie Vicious

Violet Blue

Virginia Dare

Vivian Valentine

Wanda Cummings

Warren Warder

Wendi Knight

Wendy Devine

Wesley Pipes

Whitney Valentine

Whitney Wonders

William West

Winter Lane

Woody Long

Xavier Oliver

Xena Fabio

Yasmene Milan

Yoko Heart

Yolanda Bernardo

Yvette Frances

Yvonne Paradise

sex trivia

The penguin only has one single orgasm in a year.

The rhinoceros has a penis about two feet long.

The Black Widow spider eats
her mate during or after sex.

Zachary Adams

Zandy Rose

Zarah Lee Stone

Zed Chopper

Zo Lee

Zoe Belmont

Zoe Young

Zora Banx

sex trivia

Eating the heart of a male Partridge was the cure
for impotence in ancient Babylon.

The left testicle usually hangs lower than the right for
right-handed men. The opposite is true for lefties.

It takes a sperm one hour to swim seven inches.

The initial spurt of ejaculate travels at 28 miles per hour.
By way of comparison, the world record for the 100 yard
dash is 27.1 miles per hour.

MORE FROM NICOTEXT

The Pet Cookbook
Have your best friend for dinner
91-974883-4-8
Humor/Cooking

Domesticated Delicacies from Around the World

On a global scale, one man's pet is another man's supper, and this wild cookbook shares the best recipes from around the world on how to prepare those delectable little dishes from the domesticated animal kingdom. Scorpion Soup with a Sting, Pony 'n' Pepperoni Pizza, Parrot Piroge, and Goldfish Tortilla Wrap are just a few samples of the eclectic world cuisine within. Decidedly not for vegetarians

*No animals were hurt during the making of this book.

The Bible About My Friends
91-974396-4-9
Humor

Things You've Always Wanted to Know But Have Been too Scared to Ask This book is about your friends and everything you've always wanted to know about them -- featuring simple, funny, entertaining questions for your very best friends to answer. These are questions about who they really are, about their dreams, hopes, plans and, not least, their secrets. You know, things you've always wanted to know about them but have been to scared to ask. This book will bring out the worst and the best about those you thought you knew.
Together you will laugh at the answers for years to come. That is, if you're still friends...

The World's Coolest Baby Names
91-974883-1-3
Pop Culture

A Name Book for the 21st Century Parent

A perfect name guide to spice up any baby shower name game. Baby names aren't handed down anymore, and the coolest names a much from pop culture as from the Bible. Hybrid names from popular and arcane sources in literature, television, and film create some very memorable name combinations. Includes the amusing trivia behind the names' origins and is sure to spark scads of arguments i expectant families everywhere!

Gordon Gecko - Wallstreet - Kissy Suzuki - you only live twice -

Bobby Peru - wild at heart - Holly Golightly - breakfast at tiffany's -

Alexander de Large - a clock work orange - Phoebe Buffay - friends

MORE FROM NICOTEXT *

CONFESSIONS
Shameful Secrets of Everyday People
91-974396-6-5
Humor

Eavesdropping in the Confessional

Like being a fly on the wall in any church confessional, these incredible real online admissions of people's darkest secrets are alternately disturbing, whimsical and hilarious. Sure to spark interesting conversations, this is the perfect therapeutic gift to share with friends and loved ones (and perhaps detested enemies, with certain confessions circled in red and "I know your secret" handwritten nearby).

BLA BLA - 600 Incredibly Useless Facts
Something to Talk About When You Have Nothing else to Say
91-974882-1-6
Humor

A Know-It-All's Handbook

Everyone needs something to blurt out during uncomfortable silences and ice-breaker moments. This fascinating handbook of hilarious, arcane and bizarre tidbits will make its bearer a hit at party conversation and trivia contests.

Cult MovieQuoteBook
91-974396-3-0
Humor/Film

A Film Buff's Dictionary of Classic Lines

Over 700 memorable, provocative, hilarious and thought- provoking quotes fill this fascinating guide, a kind of dictionary for movie quote buffs. Going beyond the old standards such as "Here's Looking at You Kid," this handbook pulls quotes from a surprisingly eclectic variety of global cinematic gems, and will have even the most diehard movie buffs frantic to place the line with the film.

Dirty MovieQuoteBook
91-974396-9-X
Humor/Film

Saucy Sayings of Cinema

With over 700 saucy, sexy quotes from the funniest and most sordid films ever produced. A movie quiz game in a book. An excellent source of fresh pick-up or put-down lines, this titillating guide is sure to put anyone in the mood for love.

*NICOTEXT Books are available wherever books are sold.

NICOTEXT Books are available to the trade through all major wholesalers and SCB Distributors. 800-729-6423